Happy Birthday Nissa

Love -
Mom and Dad
September 2008

D1247440

# Christmas Ornaments

# Christmas Ornaments

## ReCollections

### RALPH DEL POZZO AND DAVID HIGH

**COLLINS | DESIGN**

*An Imprint of HarperCollinsPublishers*

CHRISTMAS ORNAMENTS: ReCollections
Copyright © 2005 RALPH DEL POZZO and DAVID HIGH

HarperCollins books may be purchased for educational, business, or sales promotional use. For information, please write: Special Markets Department, HarperCollins*Publishers* Inc., 10 East 53rd Street, New York, NY 10022.

First Edition

First published in 2005 by:
Collins Design
*An Imprint of* HarperCollins*Publishers*
10 East 53rd Street
New York, NY 10022
Tel: (212) 207-7000
Fax: (212) 207-7654
collinsdesign@harpercollins.com
www.harpercollins.com

Distributed throughout the world by:
HarperCollins International
10 East 53rd Street
New York, NY 10022
Fax: (212) 207-7654

Designed and Photographed by Ralph Del Pozzo and David High
High Design, Inc.,140 Charles Street, No. 14A, New York, NY 10014
(212) 647-7514 highdzn@earthlink.net

Library of Congress Control Number:  2005924881

ISBN 0-06-083597-4

Manufactured in China
1 2 3 4 5 6 7 / 11 10 09 08 07 06 05
First Printing, 2005

**THANK YOU** to all the unsung artisans who created the unique works of art included in this book—in many cases before we were born. Antiques! Every inch of their homes served as working studios with the entire family taking part. Together they created heirlooms for you and me, our parents, their parents, as well as future generations. They were true artists in every sense and we are very grateful.

**RALPH** would like to thank: My mother, Nancy, for adorning every room in our home for Christmas with different "Theme Trees" and also inventing the "Easter Egg Tree" because her "Valentine Tree" was up too long. (Just my opinion.) My father, Ralph, for teaching me that there's nothing wrong with working seven days a week. Joseph Trusso, my therapist, for teaching me that life is too short to work seven days a week. My cousin Renee Del Pozzo for teaching me that it's not the length of our life that's important, it's how we fill it. Carmine Del Pozzo, "Gramp," for never following through on his threat to "fix my wagon." Ronald and Linda Broast for always allowing us last-minute entry onto the cutest little tree farm in the Hudson Valley (and not batting an eye when we needed another tree in March). Collier's Cold Spring Tree Farm for the best wreaths and garland this side of the Hudson River. All the flea market dealers who scurry to garage sales before sunrise so they can sell me their treasures that afternoon (at a fair price, of course) and pats4ever39 and june_apple for re-establishing my faith in eBay. David for having more faith and confidence in me than I did. You are responsible for materializing my dreams. **CYMK, Inc.** (641 Washington St. New York, NY) and Julie Sanon and the gang, for consistent, quality film and developing, always with a smile.

**DAVID** would like to thank: My mother, Arlene, and father, "Dr. Jam," for giving me unlimited love, support, and the freedom to become *whatever* it is that I have become. I will always look to you for inspiration, consolation, and, most importantly, humor and entertainment. Ralph for being the most creative, determined, and dedicated partner ever—way beyond my wildest expectations. I could never have done it without you. Terry and Shirley Lefever for putting us up and putting up with us during our marathon Pennsylvania flea market binges. Joey for showing me the magic of Summer. Cheri Dorr for "sake-n-sushi" nights. Chris Hiller for always listening and making me second-guess everything. Ruth Marten for forcing me to go to museums and that first bike ride every Spring. Linus for being my constant companion and the little brother I never had. Jack's Stir Brew Coffee for iced coffee all year to get me going in the morning.

**HIGH DESIGN** would like to thank: Laurie Rippon. We cannot thank you enough for having the vision and the faith to embark on this project with us. Hugs and kisses. Kimberly Carville, Ilana Anger, and Roni Axelrod for their patience and hard work. Roberto de Vicq de Cumptich for his insight. Dan Halpern for bringing us on board, it has truly been a privilege. And those who played a role in some shape or form in the evolution of this book, even if they didn't know it: Cheryl Balfe Del Pozzo and kids: Joseph and Brittany; Cynthia and Stuart Del Pozzo; Mark and Kassondra Del Pozzo; Michael and Regina Del Pozzo; The Hedden kids: Kristin, Jason, Sean, and Lauren; Robert Jr. and Michelle High; Zip and Janet Leh; Eddie Magee and Kathleen the prom queen; Lola McKnight; James and Mary Helen Shannon; and Lauren Topelsohn.

**RALPH WOULD LIKE TO DEDICATE
THIS BOOK TO THE MEMORIES OF**

*"Nanny" Caroline Del Pozzo*

for teaching me how to be creative in the kitchen

*"Grandma" Annie Magee*

for teaching me how to be creative everywhere else

**DAVID WOULD LIKE TO DEDICATE
THIS BOOK TO THE MEMORIES OF**

*"Grandma Sally" High*

she is up there sitting outside on a picnic table, making
milkweed-pod ornaments with little plastic deer and angels

*"Grandma Leh"*

she is looking down from that beautiful old house
on the creek, still talking about my muddy shoes

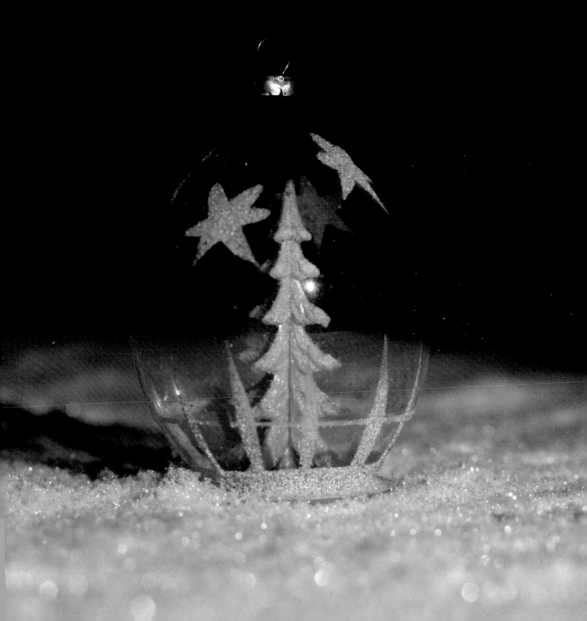

Throughout years of collecting we've absorbed tidbits—some true, some not so true—about vintage ornaments from numerous sources. Every dealer has a story to tell and although we're not dealers (yet) we do have a few stories of our own. If you're thinking about collecting and you want hard facts and values, the books listed here are from our own collection and we highly recommend them:

Brenner, Robert. *Christmas:1940–1959.* (2nd edition) Atglen, PA: Schiffer Publishing, 2002 & 2004.

Brenner, Robert. *Christmas:1960–Present.* Atglen, PA: Schiffer Publishing, 2002.

The Editors of *LIFE. The Life Book of Christmas.* Volume Three: *The Merriment of Christmas.* New York, NY: Time Inc., 1963.

Johnson, George. *Christmas Ornaments, Lights, and Decorations.* Paducah, KY: Collector Books, 1987.

Johnson, George. *Christmas Ornaments, Lights, and Decorations.* (volume three) Paducah, KY: Collector Books, 1997.

Johnson, George. *Pictorial Guide to Christmas Ornaments & Collectibles.* Paducah, KY: Collector Books, 2004.

King, Constance. *Christmas Antiques, Decorations and Traditions.* Woodbridge, Suffolk, UK: Antique Collectors' Club, 1999.

Moore, Clement C. *A Visit From St. Nicholas.* (reprint). New York, NY: Spalding & Shepard, 1849.

*Sears. 1959 Christmas Book.* Philadelphia, PA: Sears, Roebuck and Co., 1959.

Serbenz, Carol Endler and Johnson, Nancy. *The Decorated Tree.* New York, NY: Harry N. Abrams, Inc.1982.

If you're a Christmas buff—collector or not—here's the Web site of a great club with a wonderful newsletter and even a convention! The Golden Glow of Christmas Past: www.goldenglow.org

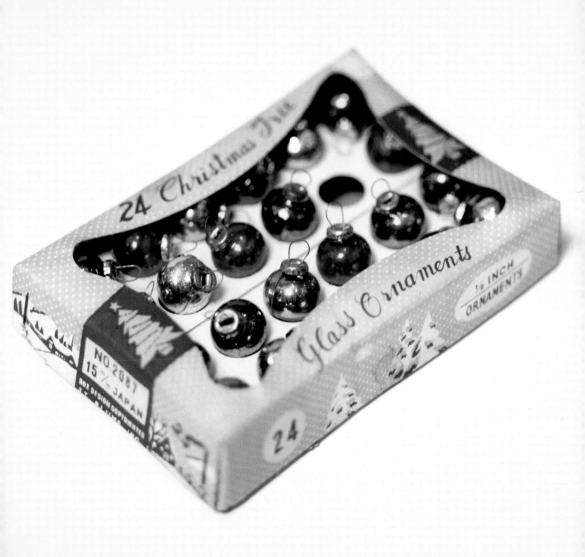

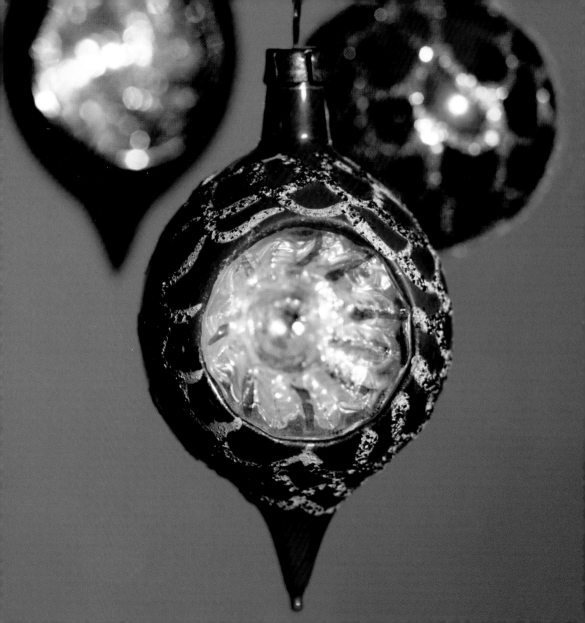

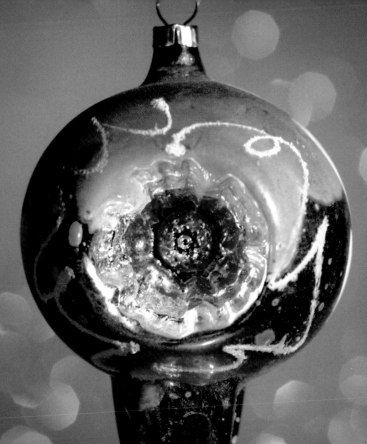

The phrase **CHRISTMAS TREE ORNAMENTS** contains the word *ornament,* which is defined as "an accessory used to beautify, enrich, or improve the appearance or general effect of an object." Ornaments on a tree are an adornment or embellishment. Decorative by nature, they lend beauty or attractiveness to the Christmas tree.

**Decorating Christmas trees with ornaments dates back to the 1500s:** The Germans started it all by decorating a wooden pyramid with greenery and other objects. In Latvia around 1510 a fir tree was adorned with roses, which were associated with the Virgin Mary. In 1605 a tree was brought indoors in Strasbourg, France, and decorated with paper roses, wafers, nuts, lighted candles, and sweets. Later decorations in England and America would include painted eggshells made into bird's nests, cookies, and candies. Glass ornaments did not appear until around 1860, again in Germany, with colors often in luscious pastels in an effort to mimic the earlier edible confections. By the nineteenth century, toys, bells, garlands, and paper ornaments—such as flags from around the world—were popular decorations.

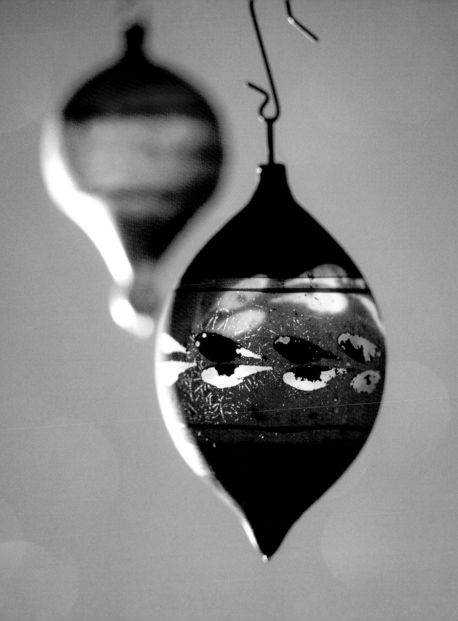

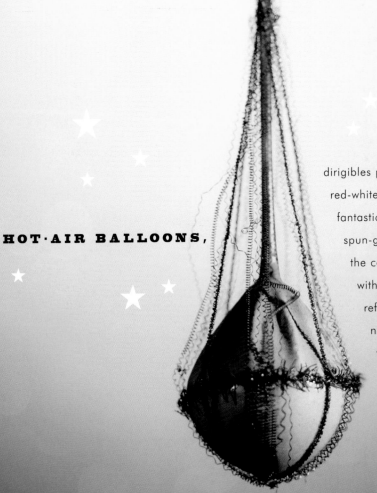

**HOT·AIR BALLOONS,** dirigibles painted with patriotic red-white-and-blue decorations, fantastical flying machines (with spun-glass wings and Santa in the cockpit), and even a kite with Einstein's face were all reflections of the Victorians' newest preoccupation of taking to the air.

Season's Greetings

*from our house to your house*

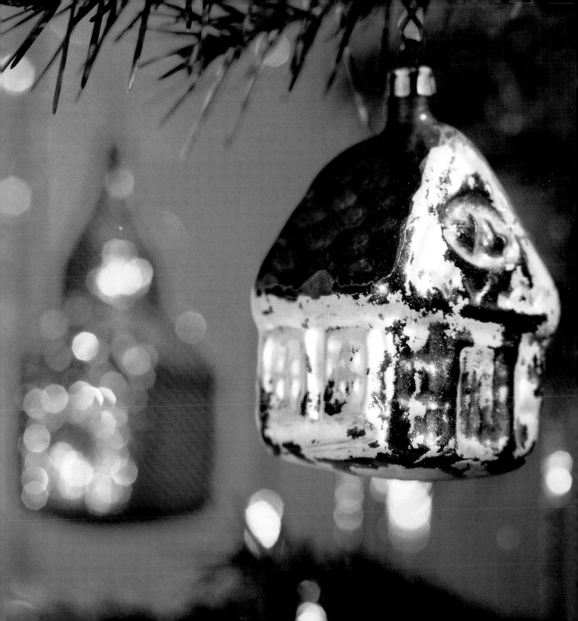

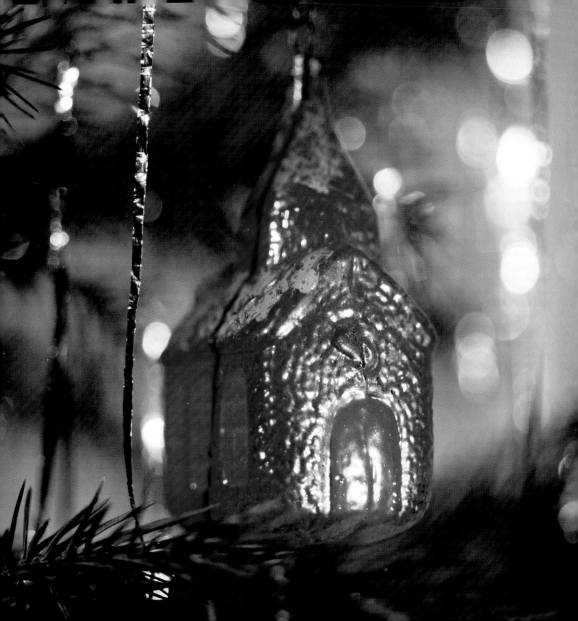

**HOOKS** were originally heavy-duty and very well made. As a selling point, manufacturers would sometimes provide hooks in their own envelope underneath the ornaments ...with the exact amount to match the number of ornaments in the box. Instructions were clearly printed on the outside of the envelope, just in case you didn't know what to do with them.

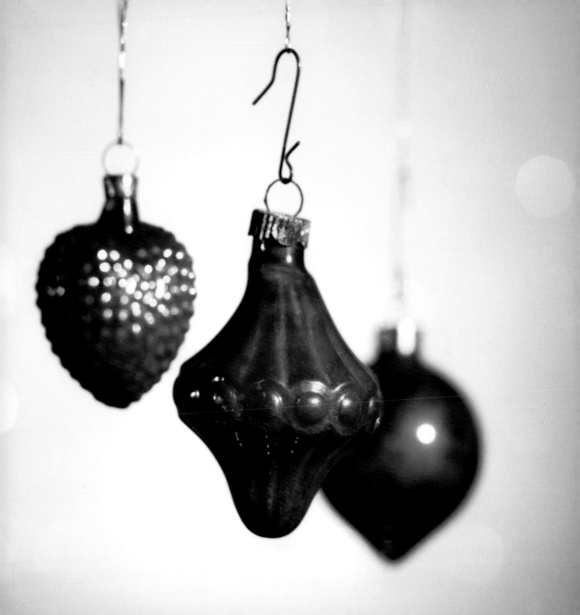

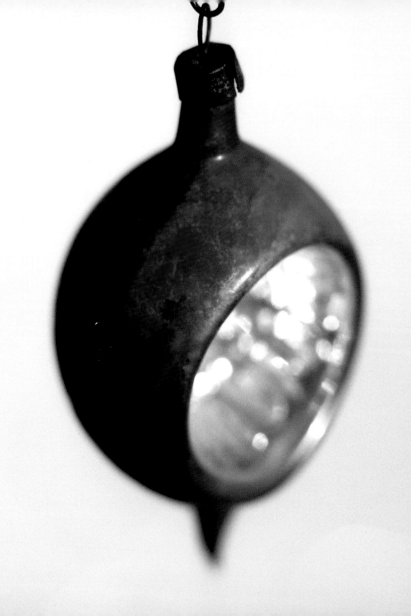

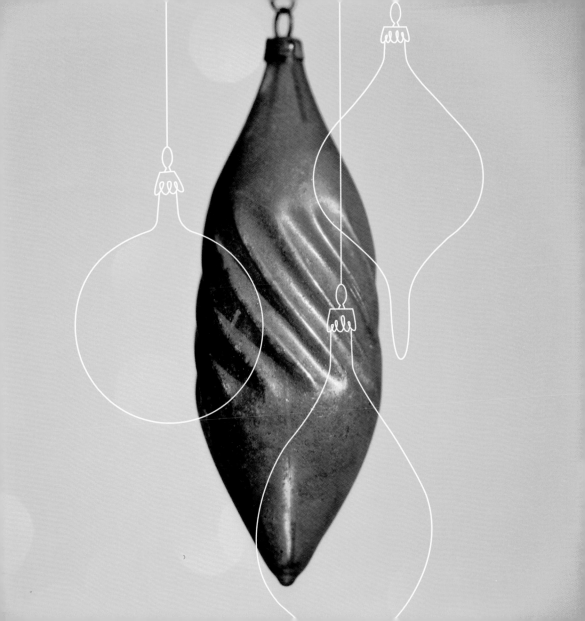

During World War II, metal couldn't be wasted on silvering ornaments. TINSEL was employed to lend a SPARKLY effect to the newly American made clear creations. As the war progressed and supplies became more scarce, even the metal caps had to go. Some manufacturers turned to paper caps; some resorted to using a string anchored inside the ornament by a matchstick.

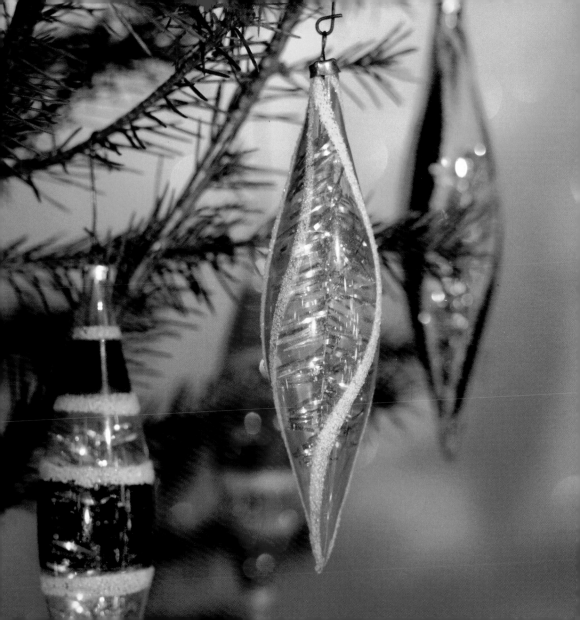

CUSTOM
MADE
FOR
AMERICA'S
FINEST
STORES

EXTRA LENGTH
ICICLES

DOUBL-GLO®

NET WT. 2 OZ.

F-I-R-E-P-R-O-O-F

*TRADE MARK REG.    MADE IN U.S.A.

Both of us grew up with family **DACHSHUNDS**—the "it" dog of the early-seventies suburban set. The Del Pozzos had Schenley; the Highs had Ludwig von Doodlesocks (a.k.a. "Louie"). Being the scavengers of the dog world, they shared an identical lust for any stray **ICICLES** that would find their way down into their foot-high universe. The old kind. Made with lead. Banned in the U.S. for extreme toxicity, it's safe to say a fair amount of brain cells were killed in those dogs. The worst part by far was the way those icicles would eventually make their way out of the pups. Not pretty, but an inevitable part of the holiday festivities.

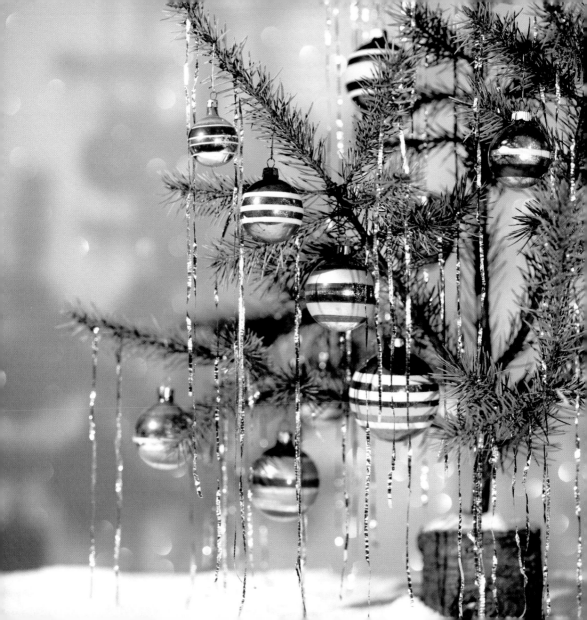

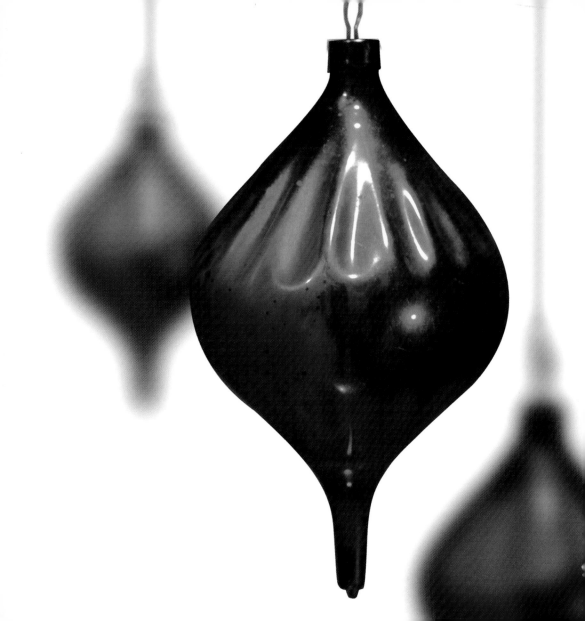

# Highball Glamour!

From 1914 to 1919, with the U.S. cut off from Germany, $\mathbf{JAPAN}$ jumped on the ornament bandwagon and quickly became responsible for 93% of the ornaments being imported into the country. The use of chenille, cotton figures, and "bottle brush" trees makes these ornaments relatively easy to identify. When World War II was declared between the U.S. and Japan, the ornament business shifted once again— this time to American soil. Max Eckardt

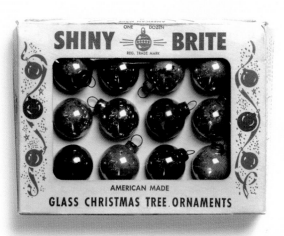

established the Shiny Brite Company in 1937 and, in conjunction with the Corning Glass Company, began producing ornaments using lightbulb-making equipment.

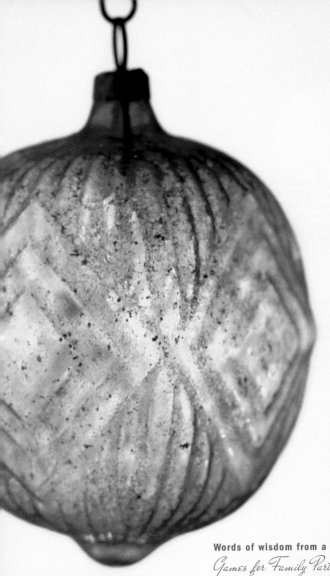

"One very great ornament of a Christmas tree is a **GILT WALNUT**. A good number hanging from the branches has an admirable effect, and they are greatly relished by the little ones to whose lot they must fall. To gild walnuts: Hammer a rather long tack or nail into the end of the walnut to hold it by, and afterwards to suspend it to the tree. Wash the nut all over with white of egg laid on with a feather. Then roll it in leaf gold till it is well covered. Mind you do not breath over the leaf gold, or it will fly away from you."

**Words of wisdom from a tiny Victorian book, edited by Mrs. Valentine:**
*Games for Family Parties and Children,* **undated.**

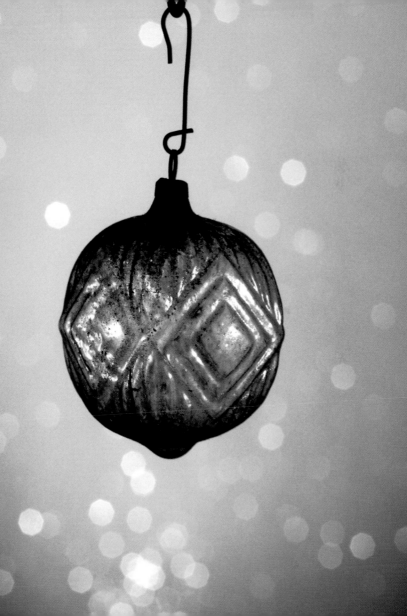

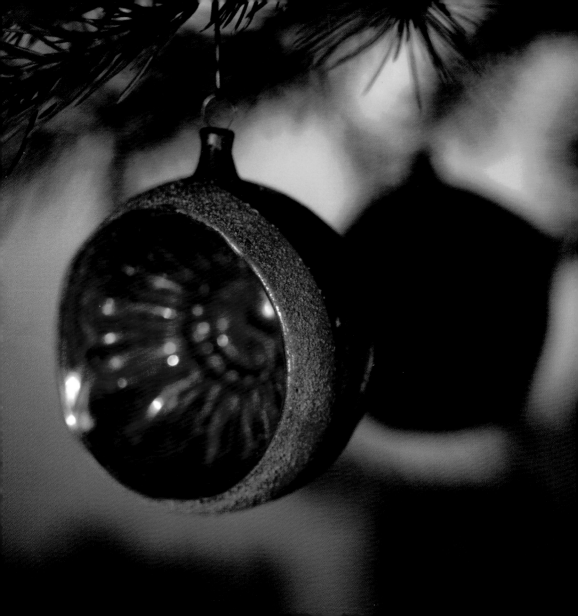

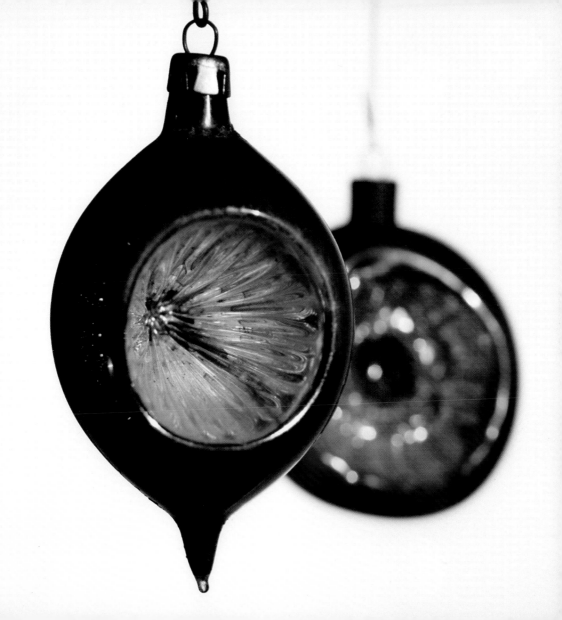

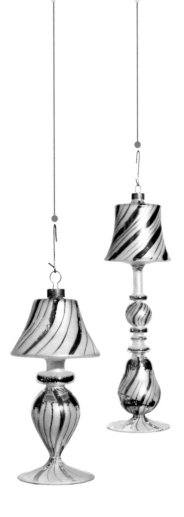

Growing up, my family didn't really "do" glass Christmas tree ornaments. Mom was always very concerned with breakage (and I also think at that time they were considered too "old-fashioned"). I do vividly remember a whole slew of **CANDYLAND**-themed ornaments. They were made of brightly colored plastic and covered in clear beads to mimic luscious crystallized gumdrops. There was a snowman, a reindeer covered in pastel-colored faux non-pareilles, cupcakes with entwined candy canes on top, and an entire candy house with a gingerbread man peeking from the window! Oh, how I loved them! Every year I would "test" each one to see if they were still made of plastic by trying to eat them...like, until I was fifteen or sixteen. I'm amazed she never put me in a special school. **— D**

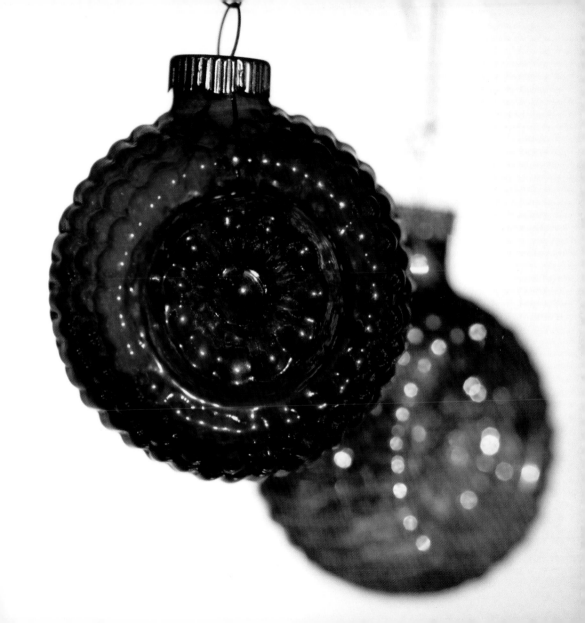

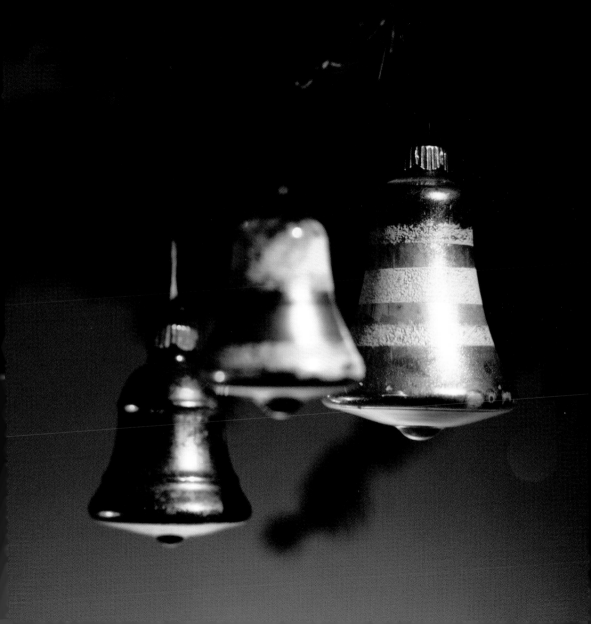

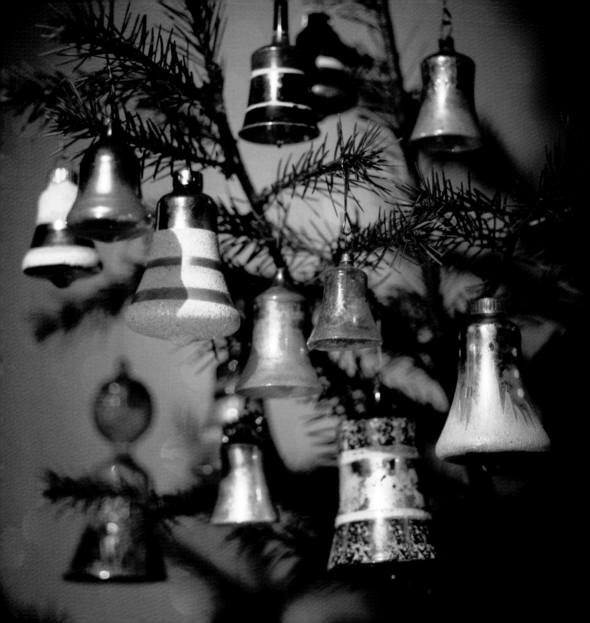

In the 1940s it became all the rage to **FLOCK YOUR OWN** tree. Thrifty, war-rationed Americans would make their own fake snow by mixing an entire box of LUX soap with two

cups of water and brushing it on freely. Upon drying, the tree would take on that much-desired "freshly-frosted-fallen-snow" look. The 1959 Sears catalog offered a tree-flocking kit that hooked up to "any tank-type vacuum cleaner having blower outlet." Magazines also offered helpful hints on tree decorating—even going so far as to suggest "painting" the tree to match the color scheme of the room!

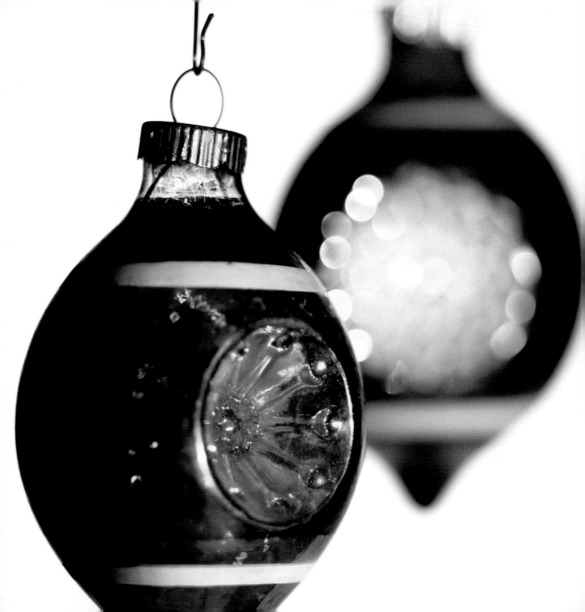

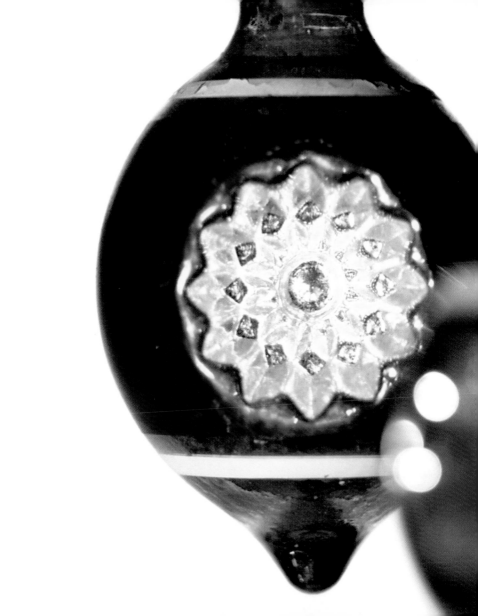

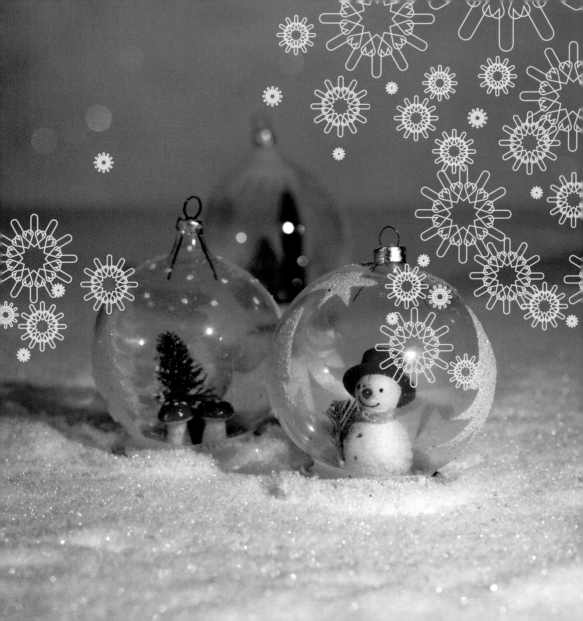

German dome ornaments were featured in the *Sears 1959 Christmas Book.*

**4** **Box of 6 Big German Ornaments.** 1 wire spun basket shape, plastic angel; 1 wire spun ship, plastic angel; 1 "jeweled" ball; 1 church under clear glass dome; 1 3-D multicolor spiral effect skyrocket reflector;* 1 ball, frosted stripes. Metal-capped glass. 2⅞ to 5¼ in. Wt. 1 lb.

49 N 6092 . . . Box of 6, **$1.98**

* Skyrocket reflector ornament is shown on next spread!

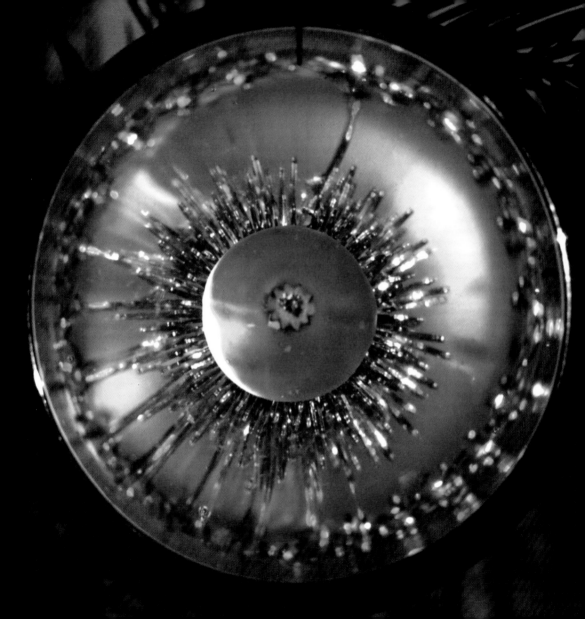

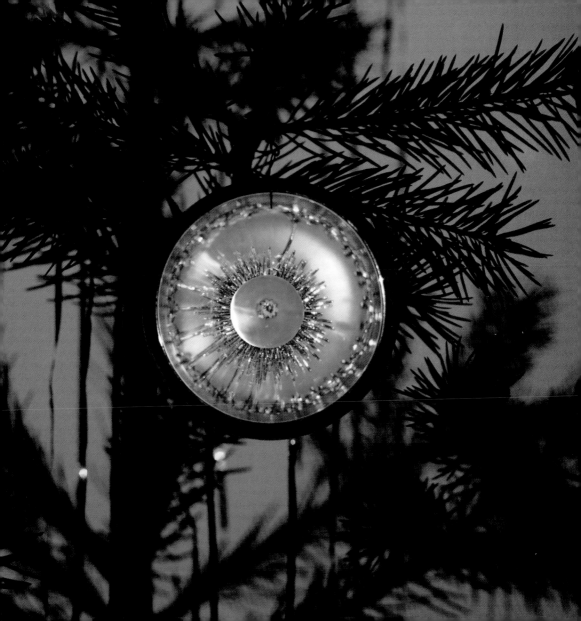

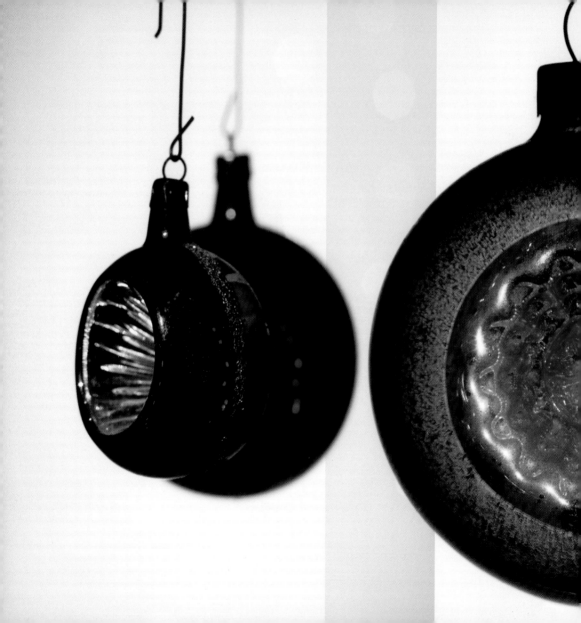

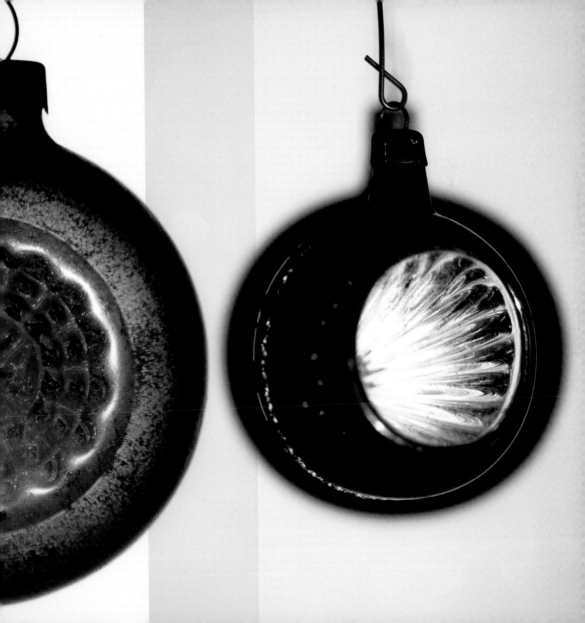

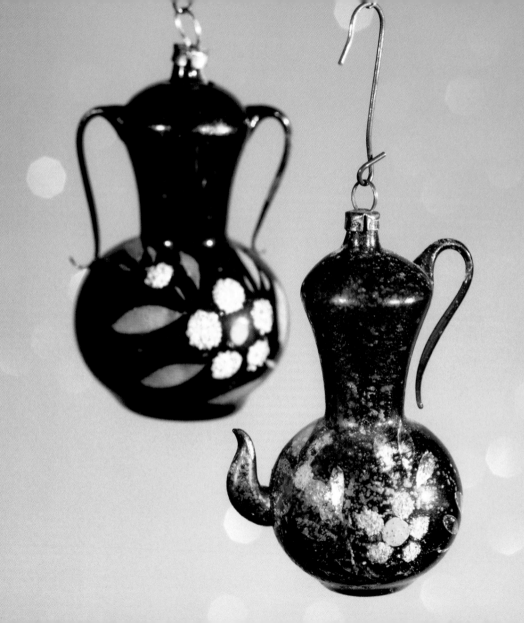

Queen Victoria's husband, Prince Albert, is generally credited
with bringing the Christmas tree to **E N G L A N D**. In 1841,
homesick for his German homeland during the holidays, he had
a tree brought indoors and decorated with every luxurious sweet
imaginable. An engraving of the tree—surrounded by children in
awe and tapers ablaze—appeared in newspapers and made the
Christmas tree the "must-have item of the season."

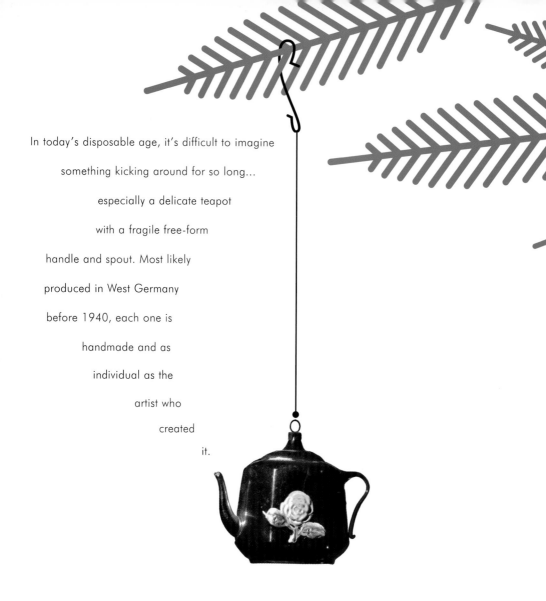

In today's disposable age, it's difficult to imagine

something kicking around for so long...

especially a delicate teapot

with a fragile free-form

handle and spout. Most likely

produced in West Germany

before 1940, each one is

handmade and as

individual as the

artist who

created

it.

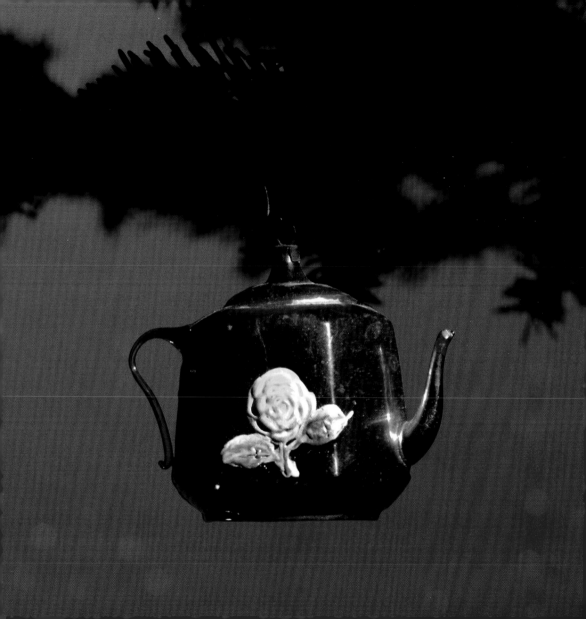

GLASS CHRISTMAS TREE ORNAMENTS

THE GEORGE FRANKE SONS CO.

BALTIMORE 1, MARYLAND

MADE IN U.S.A.

Proper storage is a must for keeping your ornaments looking fresh year after year. Remember, these are fragile little heirlooms that should be handled the least amount possible—as the oils on your fingers can be very damaging. Keep them from extremes of hot and cold and never, ever wash them! Most lacquers used on older ornaments are water-based and will wipe right off. Wrap each ornament in soft, acid-free tissue paper and place them in a single layer in a sturdy cardboard box or container.

**A mini box of ornaments (4¼" x 6" x 1½")
for use on a tabletop tree or wreath. Label
on bottom succinctly states: Japan, grade A,
one doz, 33 m/m, JESexp 160.**

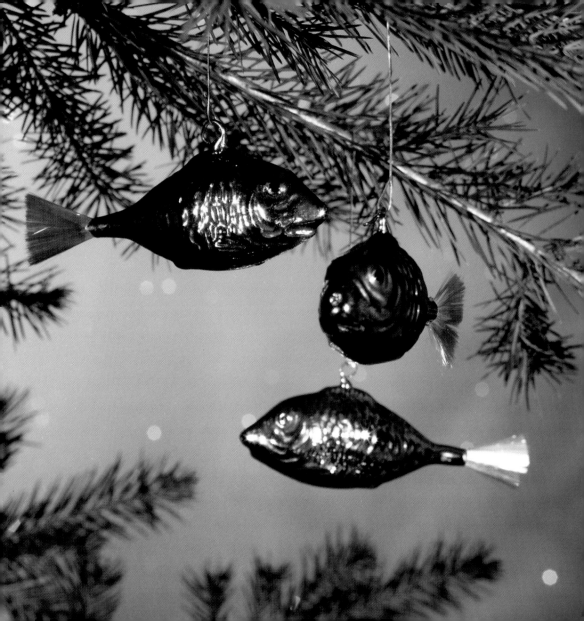

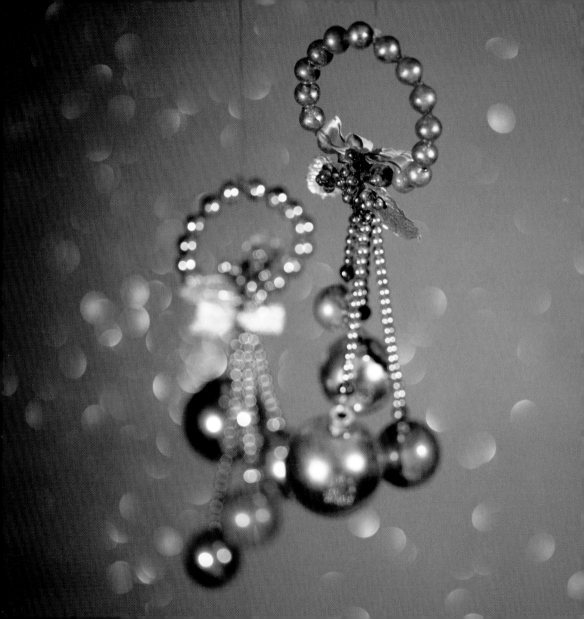

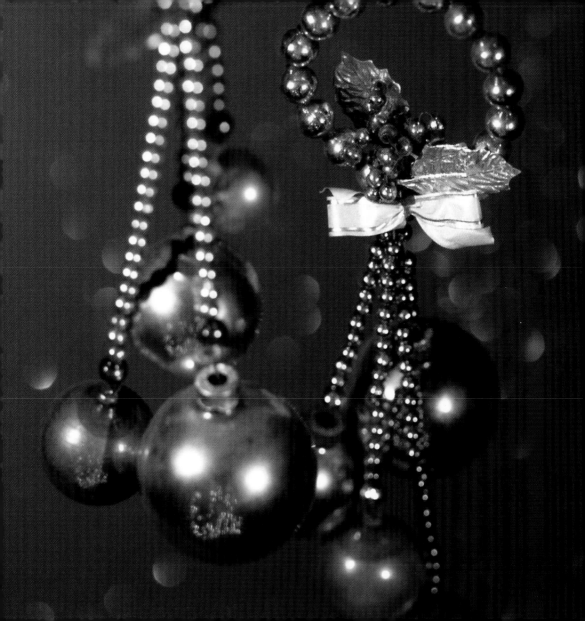

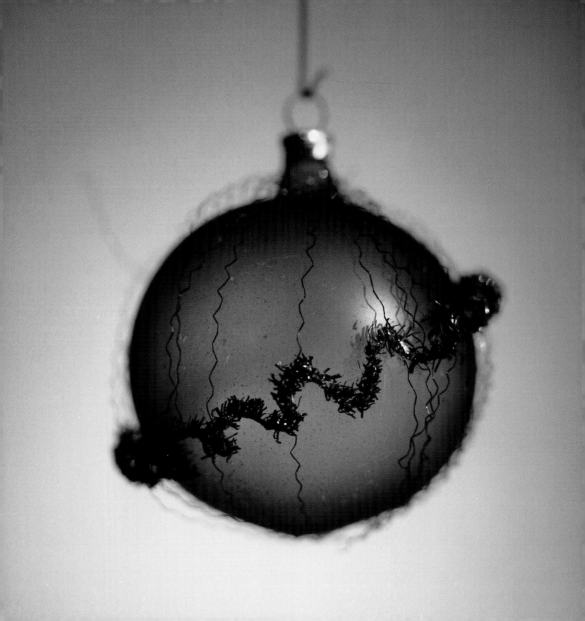

When I was growing up, I would voluntarily assume the responsibility of turning off the Christmas tree lights every night before bedtime. After crawling under the tree to unplug it, I would lie on my back and escape into the seemingly **INFINITE UNIVERSE** shimmering above—until my mother would scream, "What in the world are you DOING down there?" I still do it. Now I use Linus as an excuse. — **R**

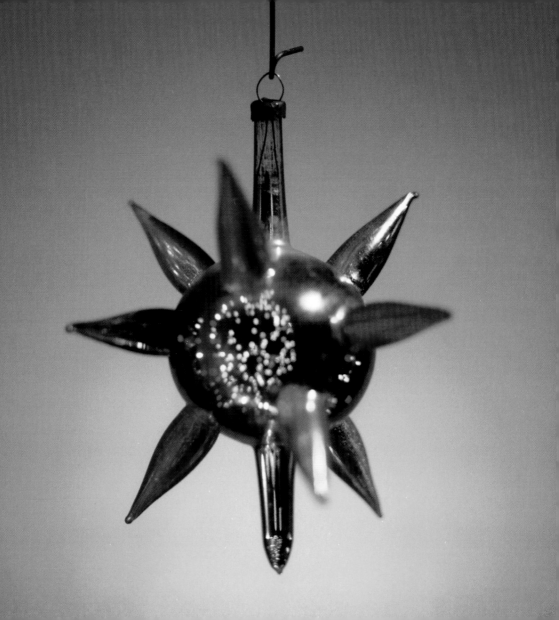

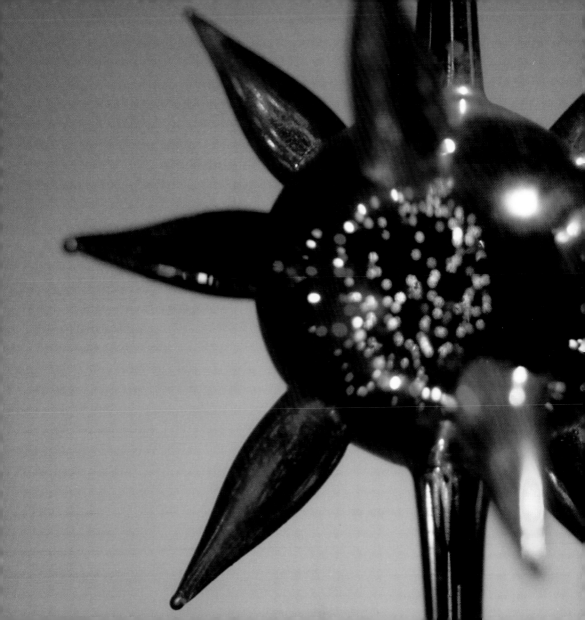

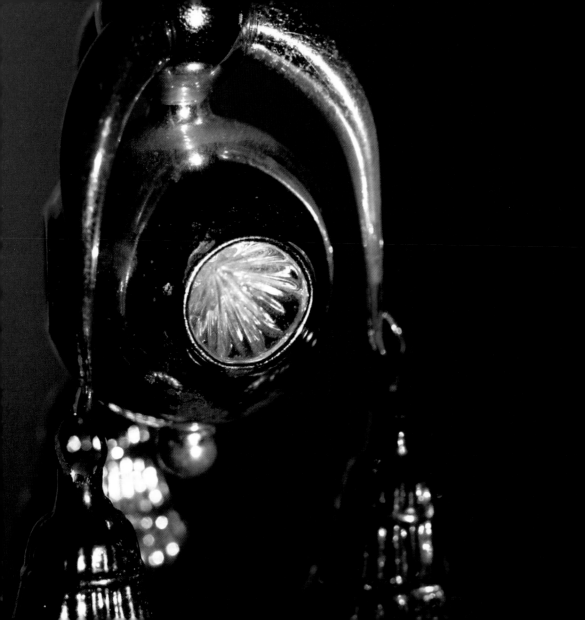

Years before *Sputnik 1* soared into space in 1957, mankind was intrigued by the secrets of the stars and what was hidden behind them. Was there artificial intelligence? Martians? ROBOTS? The allure of **SCIENCE FICTION FANTASY** permeated the public's psyche—from the very first mention of "robots" in an early 1920s New York play to movies, books, and, of all things, even Christmas ornaments.

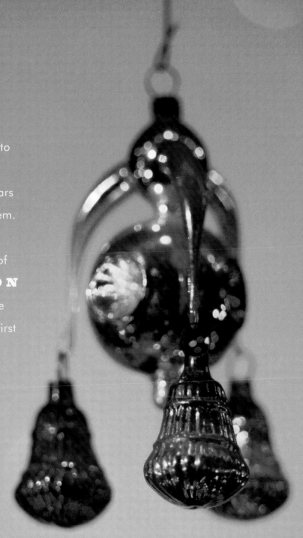

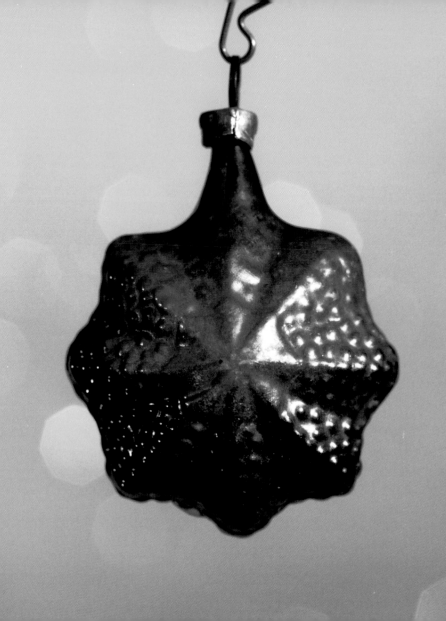

Twinkle, twinkle, little star,

How I wonder what you are.
Up above the world so high,
Like a diamond in the sky.
Twinkle, twinkle, little star,
How I wonder what you are!

When the blazing sun is gone,
When the nothing shines upon,
Then you show your little light,
Twinkle, twinkle, all the night.
Twinkle, twinkle, little star,
How I wonder what you are!

Then the traveler in the dark
Thanks you for your tiny spark;
He could not see which way to go,
If you did not twinkle so.
Twinkle, twinkle, little star,
How I wonder what you are!

Written by Jane Taylor in 1806

Judging from collectors' books, radish-heads with goofy faces were very popular ornament motifs during the Victorian era. Although we've never come across one quite like this, we have a hunch that this somewhat disturbing decoration may be a bizarre combination between a **RADISH·HEAD AND A ROBOT.** Glassblowers were free to use their imaginations when making their creations, and they were often influenced by the personalities and events of the day—perhaps in this case, rapid industrialization and a world full of clanking new-fangled machinery. They would form the screaming mouth by using a wooden paddle while the glass was still pliable. Most likely big, scary google eyes appeared where now are only vacant craters. Of course, all this could just be our imaginations running wild, and this ornament could conceivably be a singing frog (which would have the same type of mouth and were also inexplicably popular). Either way, it's pretty frightening for a Christmas tree.

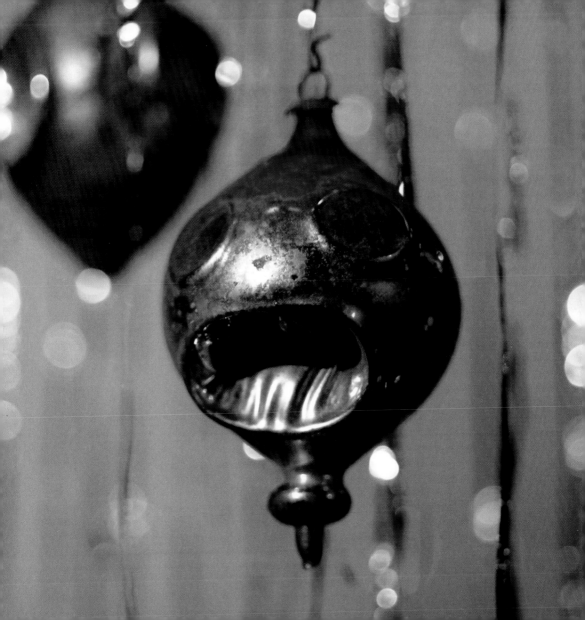

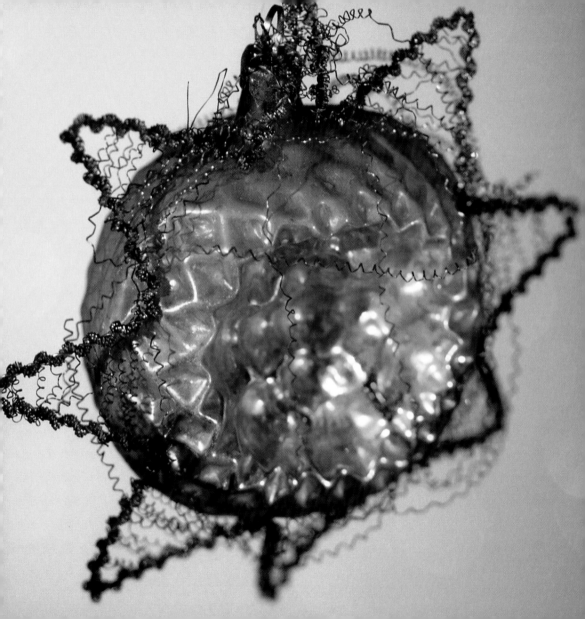

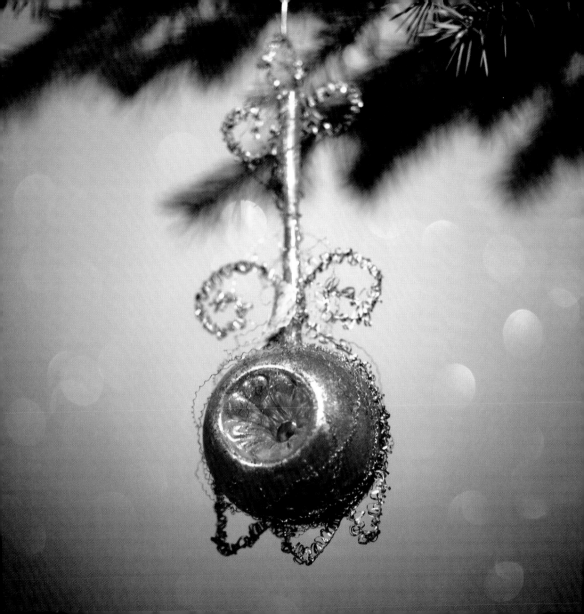

Lauscha, Germany, is considered to be the birthplace of the glass ornament industry. While factories did exist, for the most part ornament making was a family affair—with every member of the family pitching in with their very own tasks. The father or oldest sons would do the glassblowing. The mother or oldest daughters would line the insides of the ornaments with a silver nitrate solution and put them on spikes to dry. The grandfather or grandmother would paint the details by hand and add trimmings (such as yards of metal **KRINKLE WIRE,** shown on these two). Even the youngest children were called upon to take them off the spikes, add metal hangers and caps, and pack them securely for shipping.

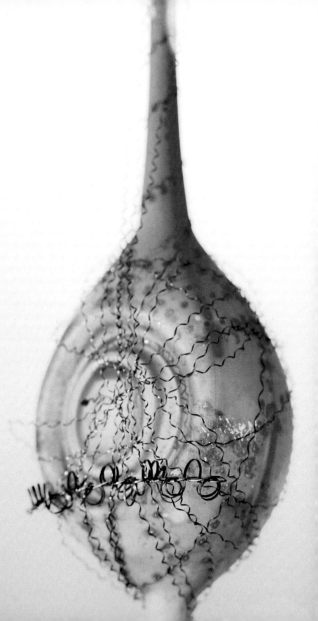

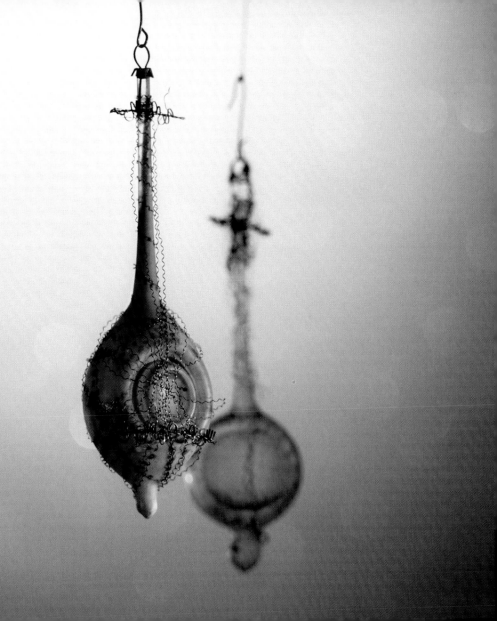

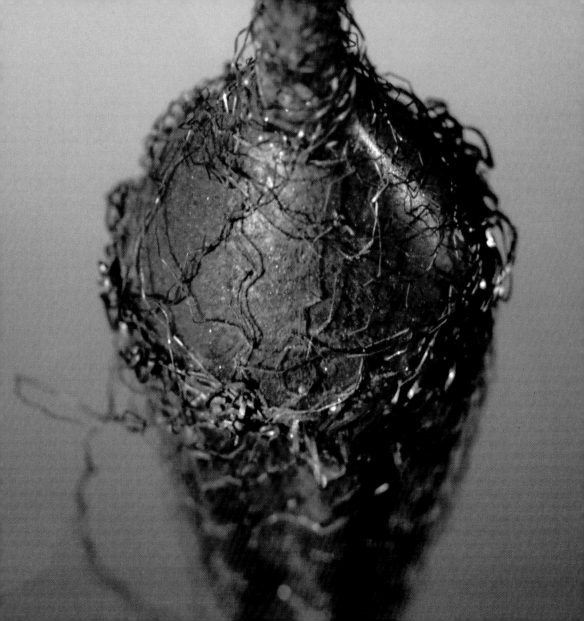

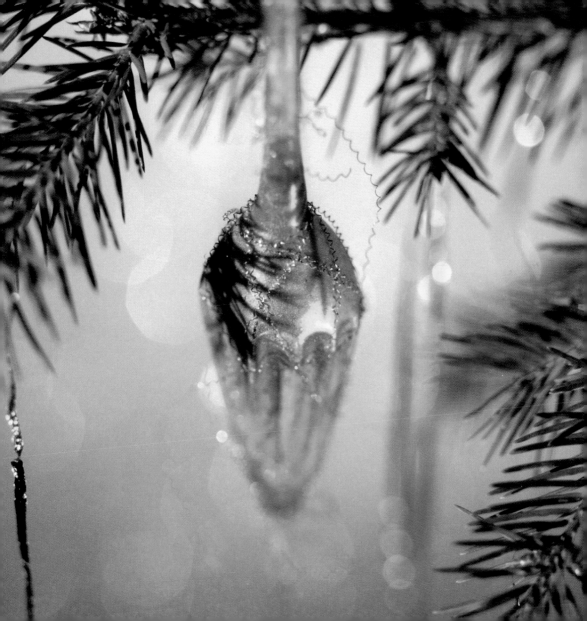

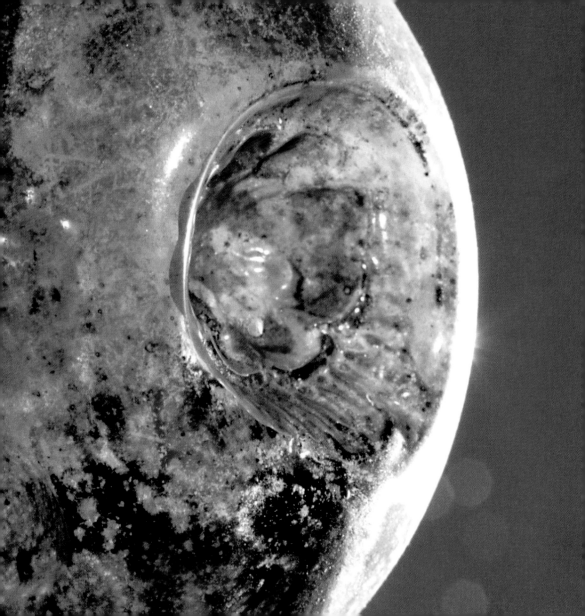

We believe this may be one of the oldest ornaments we have in our collection — circa 1800s, judging from its patina and the thinness of the glass. Although we don't reccommend it, it is said that a way to tell an old ornament from a newer reproduction is to

**TASTE IT.**

The older ornaments will leave a slightly salty taste on the tongue tip, which is missing in reproductions. Some theorize that is from the older (most likely toxic) chemicals, which are no longer used. Others suggest it is a buildup of oils from the hands of those who handled the ornament year after year as it passed from generation to generation.

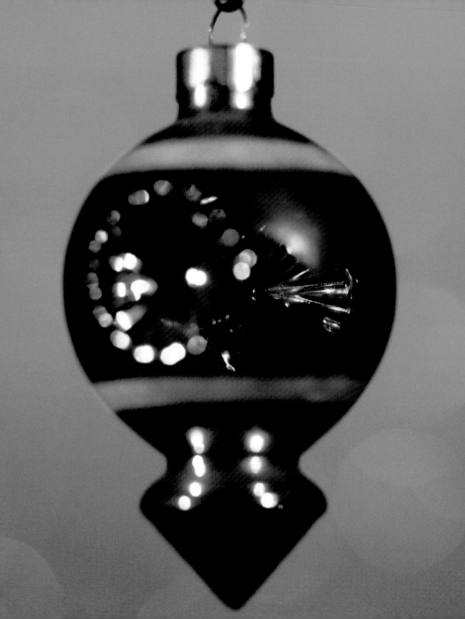

The battles we had trying to group all of us
kids for the dreaded Christmas picture.
Never saying "cheese" at the same time.

The Christmas parties, and the voices of
those who live on only in my memories.

The local guy who set up his electric
organ and drum machine in the dining
area. A band! (Almost.)

The years I stood at the top of the stairs
wishing I was old enough to be down there
dancing. The years I was old enough.

The first time I was in charge of the blender.
Those mixed drink packets:
Pink Lady, Grasshopper, Tom Collins.

**SO MANY MEMORIES HELD WITHIN SUCH**  *Fragile* **WALLS**
**(OR, RALPH WAXES SENTIMENTAL)**

The first time I drank Whiskey Sours...
The last time I drank Whiskey Sours.

Nanny's pizzelles. Francis's Italian beaded
cookies and her laugh. Oh, what a laugh.

The time my father "hurried up" the yule log
with a poker, filling the house with smoke as
guests arrived and Christmas carols played
backup to my mother's shrieks.

Waiting for Santa as a kid, playing Santa as
a teen, waiting for Santa again as an adult.

Snowdrifts taller than the bushes with a top
crust so hard you could walk on it just like
the surface of the moon.

The smell of ginger cookies.
Waiting for the broken ones.

The excitement I would feel when Grandma
Magee was coming. So simple her present
was. Always my favorite. Always something
to create.

Nanny saying, "When you grow up and
get married will you still come visit me?"
Me always saying yes.

Great-Grandma Sofield and the annual
trek to see her tree. Filling up on oatmeal
cookies (minus all the raisins gumming up
my pockets). Her Christmas tree and how
sparse it seemed with such old-fashioned
decorations. My brothers and sisters and me
fidgeting the entire time, craving all our new
toys lying dormant back home.

OH YES! THERE'S *More...*

My neighbor showing me where an angel had landed. And making them ever since.

The *Sears Christmas Book*. Making notes in the toy section for Santa, peeking at the underwear section.

Looking for tracks on the roof and tracks in the snow. The year Santa forgot to eat his cookies.

Staring at the chimney, scratching my head.

Being terrified of Aunt Dottie and Uncle Vic's tree, totally encased in an angel-hair cocoon, just like the people in that giant spider movie.

The first time I saw a fake white tree at Aunt Rosie and Uncle Paul's house.

The "new" Christmas shows: *Charlie Brown* and *Frosty* and *Rudolf*. The voice of Burl Ives.

Santa sledding over hills of snow on an electric razor during the commercial breaks.

The music, sounding so new: Nat, Rosemary, Bing, Dean, the Chipmunks, and the Slinky song.

Helping my mother paint ceramic trees and nativities. Those styrofoam balls with ribbons and beads and snow-in-a-can.

I remember everything sparkled.
I remember the memories.

Merry Christmas. Happy Memories.

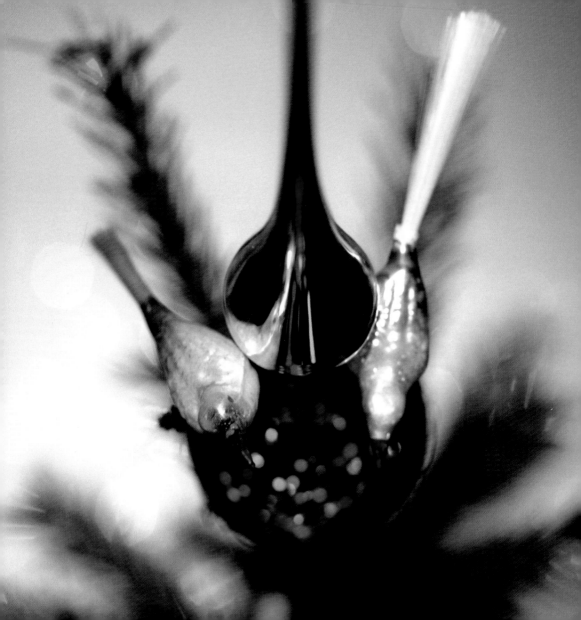

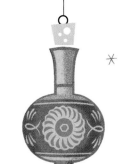

# TREE TOPPERS

aren't necessarily just for the tops of trees. If you have any extras kicking around the house (like we do), hide a cork and an eye hook inside the pike to hang it upside down as an extra-large ornament. They can prove very handy by filling in those UNSIGHTLY gaps in the tree.

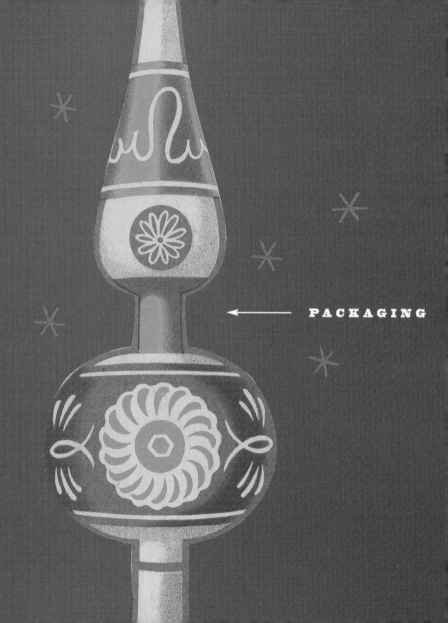

PACKAGING

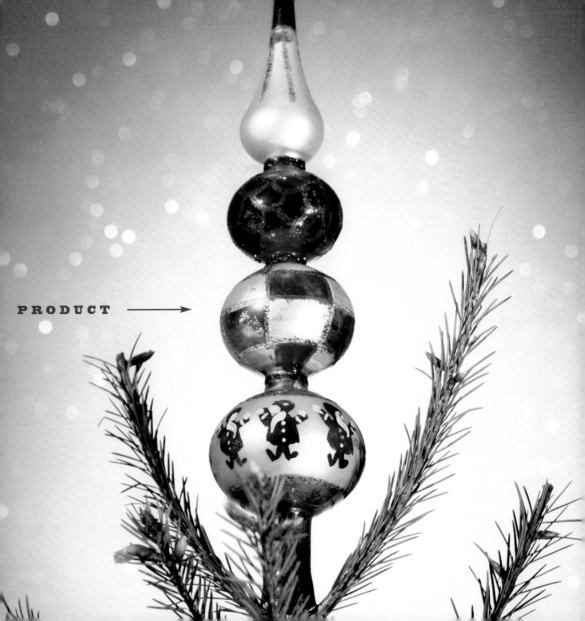

PRODUCT →

**BIRDS** played a big role in both form and function. They were produced as ornaments—usually with spun-glass tails, more unusually with spun-glass wings—in every size, shape, and color to hang or clip all over the tree. Live canaries were used in the cottage-industry shops of Lauscha, Germany, to monitor dangerous carbon monoxide fumes during the winter months when all the windows were tightly sealed. Small wooden cages were standard fixtures on the wall right next to the glassblower. (And no PETA in the late 1800s to protect them!) There is an ancient German legend that during a horrible blizzard on Christmas eve, thousands of canaries took refuge in a giant fir tree in the middle of the village, filling the noble tree throughout the night with the gift of song.

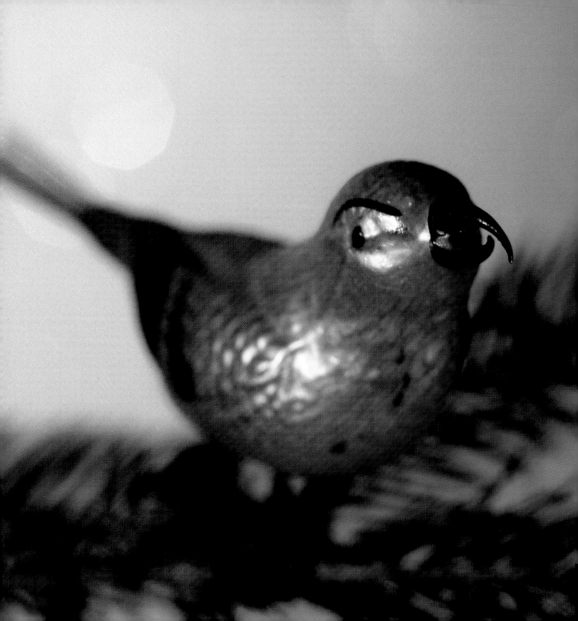

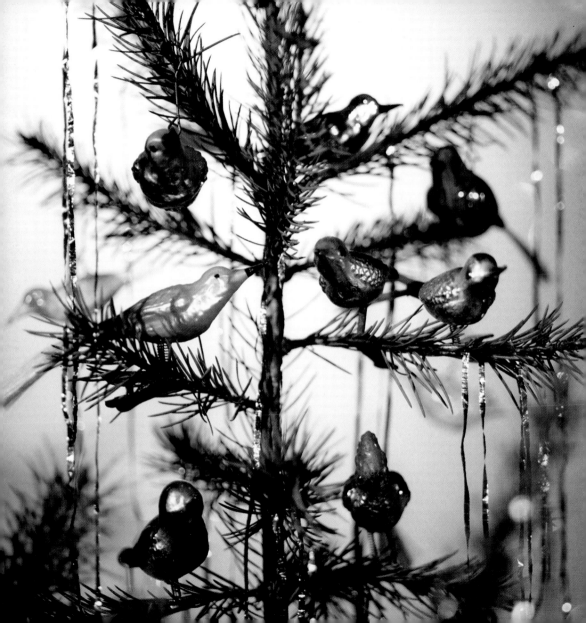

The line between Christmas and **THE MACABRE** seemed to be much more blurred during Victorian times. Owls, ravens, gourds with sinister faces, doll heads with glued-on glass "keepin'-you-up-all-night" eyes, and even devils and witches all made their appearances on the Christmas tree. In Austria and southern Germany, a devil figure called Krampus would accompany St. Nick, punishing bad children just as St. Nick would reward the good. He was known to haul little rapscallions off in sacks and boil them in cauldrons. The idea, of course, was to frighten small children and keep them in line throughout the year. How sweet.

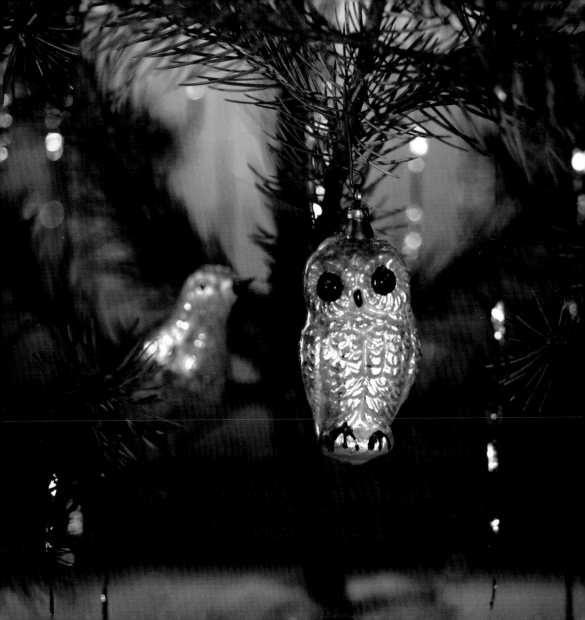

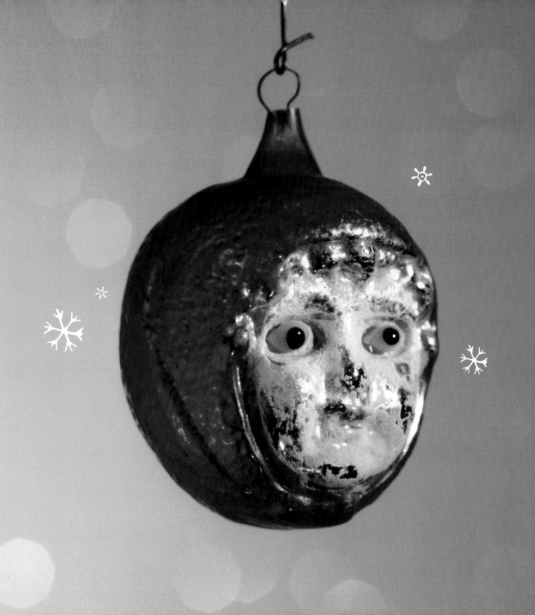

The eyes have it—and they were very popular indeed. **RED RIDING HOOD**, Joan of Arc, baby-girl heads, and even busts of the Madonna and Jesus got extra-realistic staring power with the help of glued-on glass eyes on some German Victorian ornaments. Haunting.

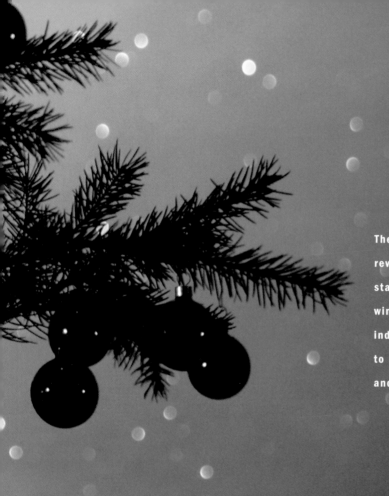

The **PAGANS** of Northern Europe revered the evergreen's ability to stay green throughout the entire winter. They would bring the tree indoors on the solstice in an effort to beat back the forces of darkness and ensure the return of the sun.

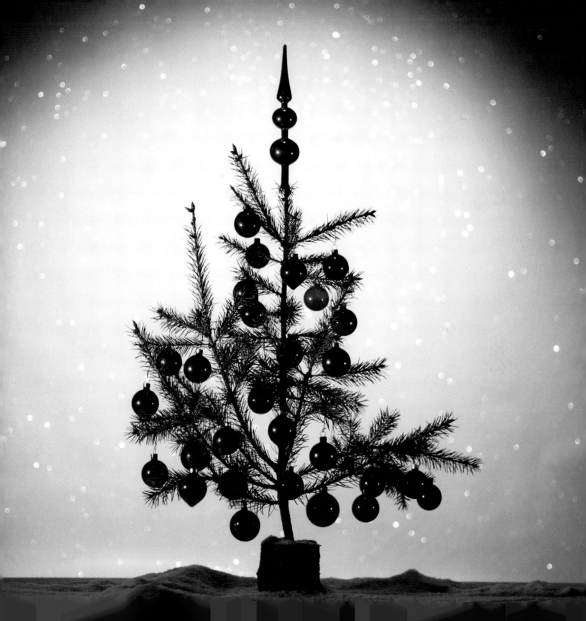

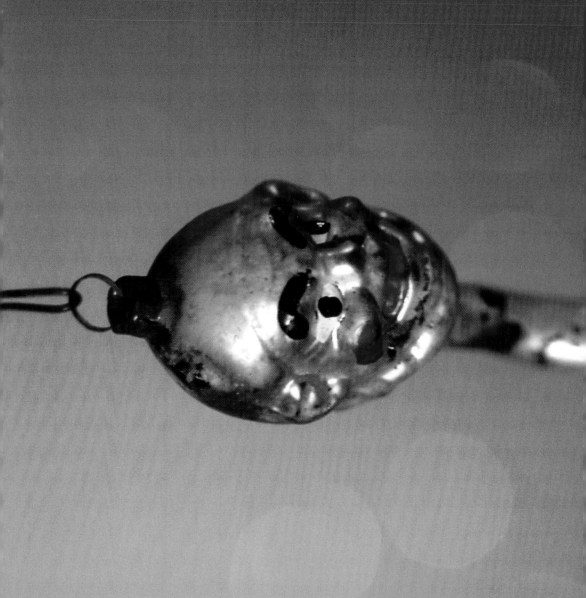

This is a **JOEY·CLOWN·HEADED SNAKE,** named after the classic clown originated by Joseph Grimaldi in the early 1800s. He was the last ornament won on eBay right before our book was due to the publisher. We really didn't think he was going to make it in time, but he was obviously bound and determined. He was also the most money we've spent (so far) on a single ornament—$187 plus shipping and handling! (I almost passed out, but Ralph just shrugged and said, "Think of it as an investment.") Since he is listed in collector books as worth $250–$275, you *could* say we got him for a song.

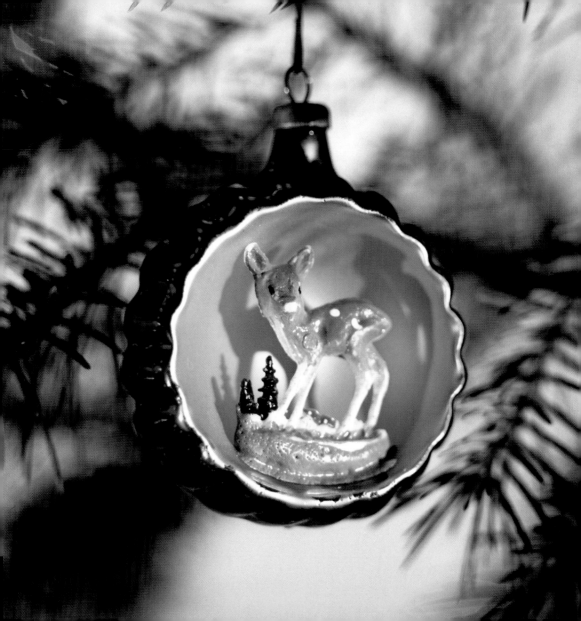

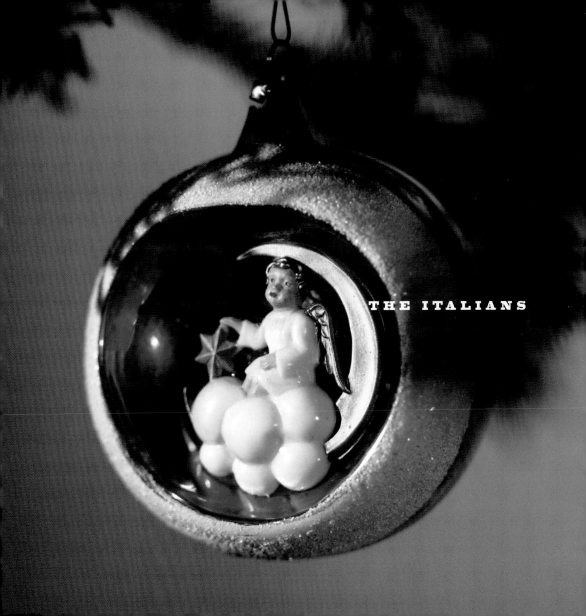

THE ITALIANS

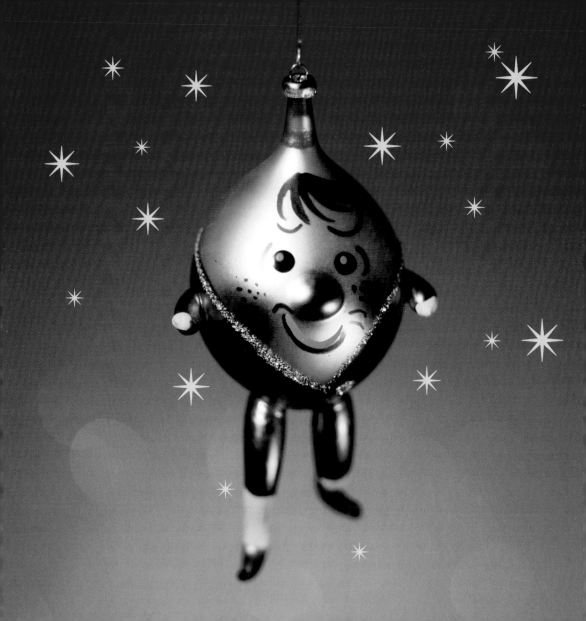

Italian ornaments are easily identifiable because they are free-blown without the use of molds; hand painted in bright colors with acute attention to detail; and they also tend to be extremely **WHIMSICAL** in their subject matter. The ages of the ornaments are somewhat easy to guess since they tend to reflect the popular American characters of the time—Peter Pan and Pinocchio in the 1950s, Neil Armstrong in the 1960s, Charlie Brown and Lucy in the 1970s.

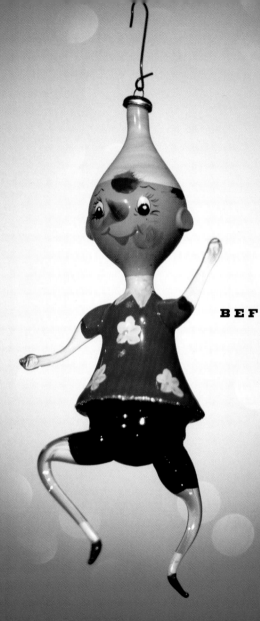

BEFORE THE LIE...

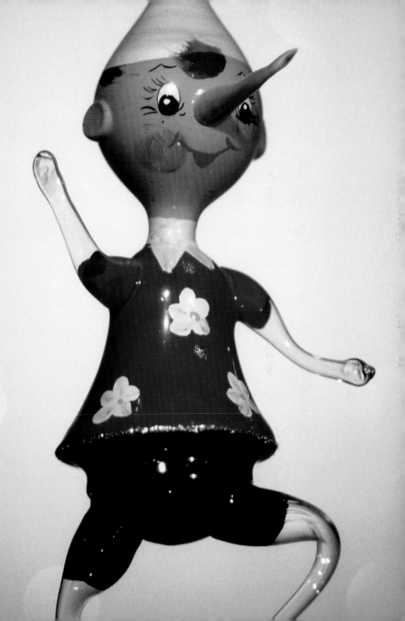

...AND AFTER

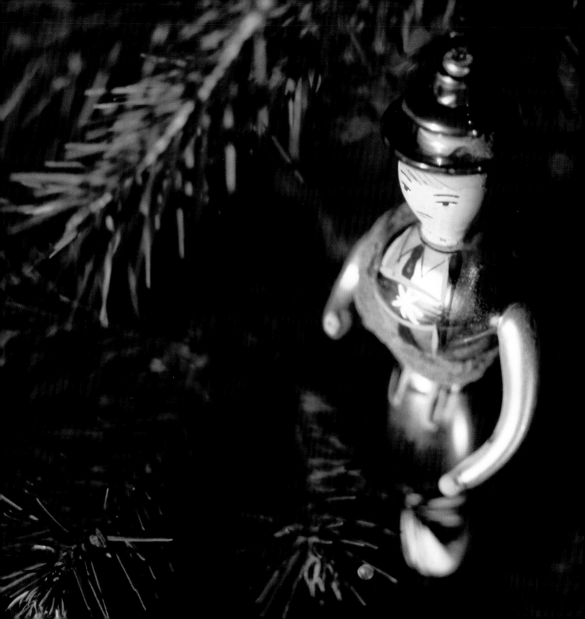

Among the very first Italian ornaments to be imported into the United States was this mountain hiker, which was part of a four-piece set sold by Sears to commemorate the **1955 WINTER OLYMPICS.** The set could also include a skier with attached wooden skis and a female figure skater with faux fur around her neck, the brim of her hat, and the hem of her skirt. The entire set originally sold for $2.98.

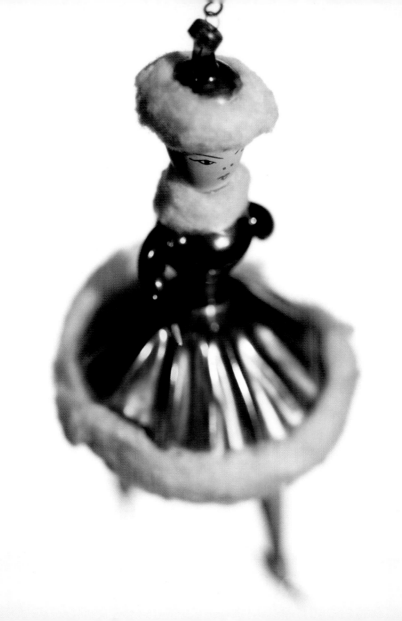

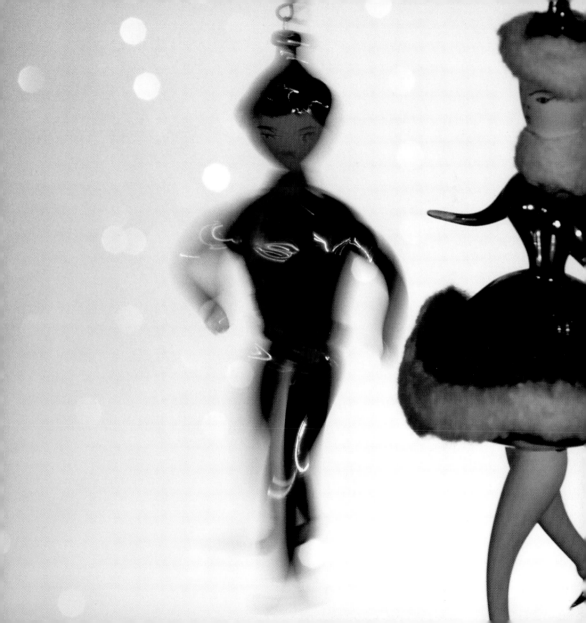

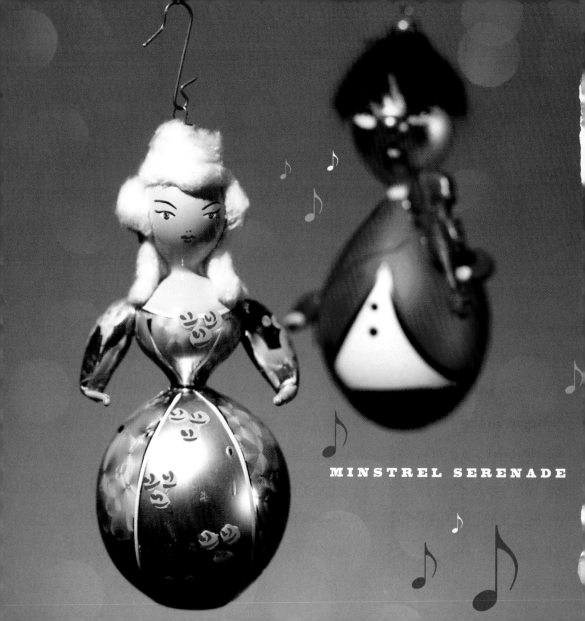

MINSTREL SERENADE

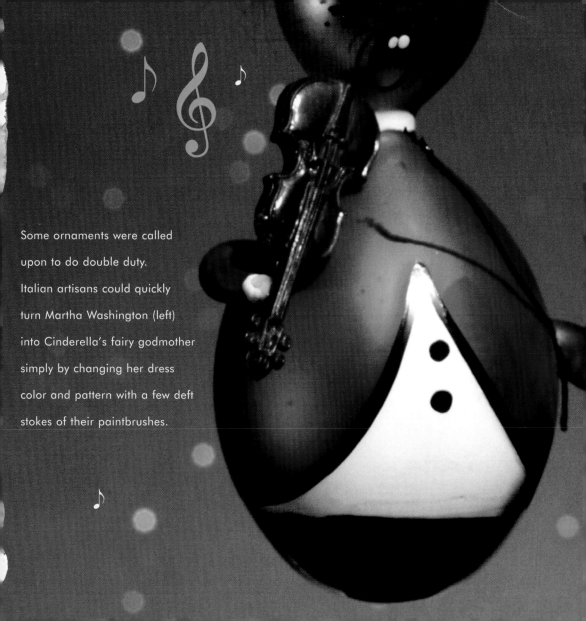

Some ornaments were called
upon to do double duty.
Italian artisans could quickly
turn Martha Washington (left)
into Cinderella's fairy godmother
simply by changing her dress
color and pattern with a few deft
stokes of their paintbrushes.

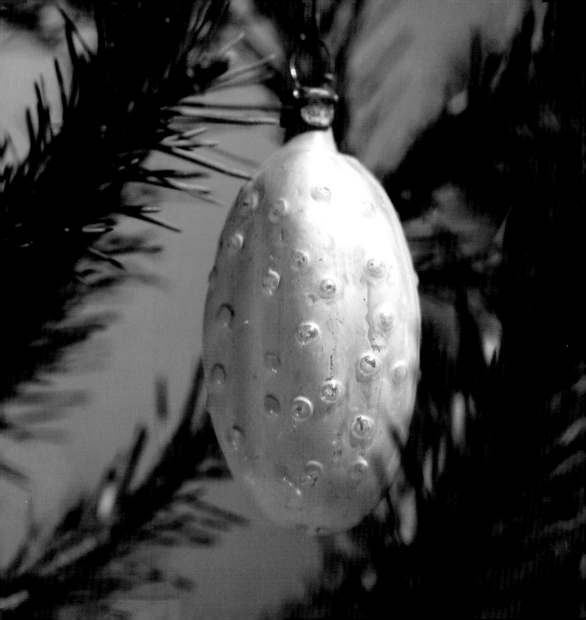

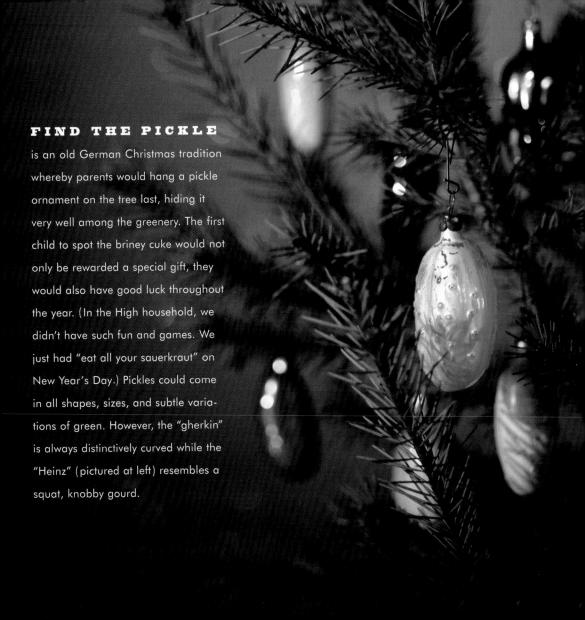

**FIND THE PICKLE**

is an old German Christmas tradition whereby parents would hang a pickle ornament on the tree last, hiding it very well among the greenery. The first child to spot the briney cuke would not only be rewarded a special gift, they would also have good luck throughout the year. (In the High household, we didn't have such fun and games. We just had "eat all your sauerkraut" on New Year's Day.) Pickles could come in all shapes, sizes, and subtle variations of green. However, the "gherkin" is always distinctively curved while the "Heinz" (pictured at left) resembles a squat, knobby gourd.

The version of **SANTA** that we have come to know and love has evolved dramatically through the years. It is a general consensus that three men played a big role in his transformation: Clement Clarke Moore wrote *A Visit From St. Nicholas* (also known as *'Twas the Night Before Christmas*) in 1822; Thomas Nast engraved images and provided "facts" about Santa for *Harper's Weekly* and *Harper's Bazaar* from 1863 to 1886; and, perhaps most influentially, Haddon H. Sundblom painted the "modern" Santa for Coca-Cola® ads from 1931 to 1964. Before them, variations of Father Christmas and St. Nicholas were often skinny, stooped, stern-faced, and grim, bearing little resemblance to the jolly fat guy we grew up with.

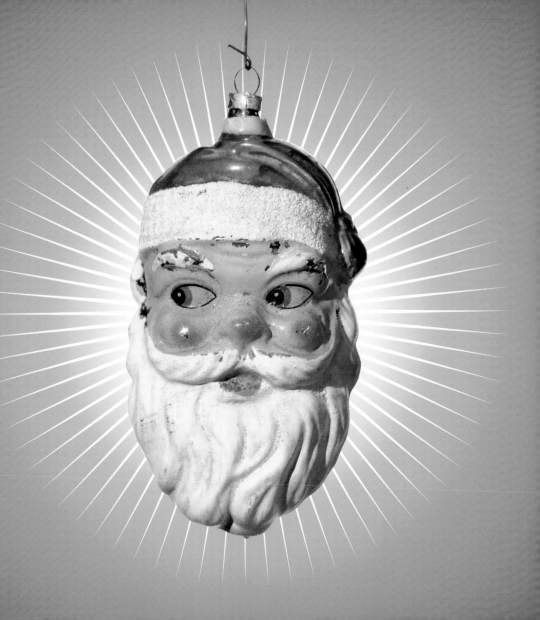

# NO WONDER KIDDIES COULDN'T
# SLEEP ON CHRISTMAS EVE...

(thinking this guy was coming down the chimney any minute).

From a reprint of *A Visit from St. Nicholas,*

by Clement C. Moore, 1849. Engravings by Boyd.

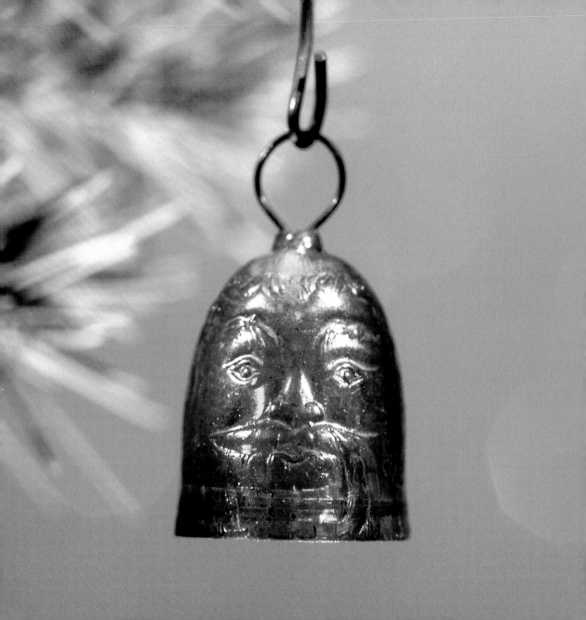

We **DISCOVERED** this one at the bottom of a box of ornaments that we won at an auction in upstate New York. It was part of a box-lot of vintage Christmas decorations, hidden under the tissue, neglected and pretty much forgotten for who knows how many years. We knew we had found a score because the flat-wire hanging loop is an indicator of *"really* old," but we actually didn't realize until years later that the face of Santa is embossed on the surface of the bell since it is so subtle (and the ornament is so very tiny). Miniature ornaments such as this were most likely used on Victorian feather trees.

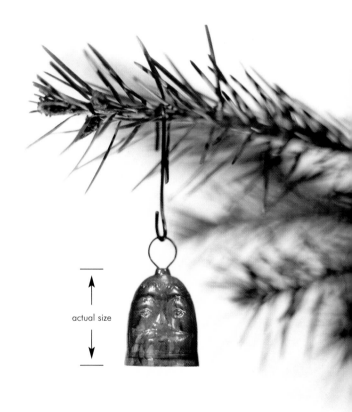

actual size

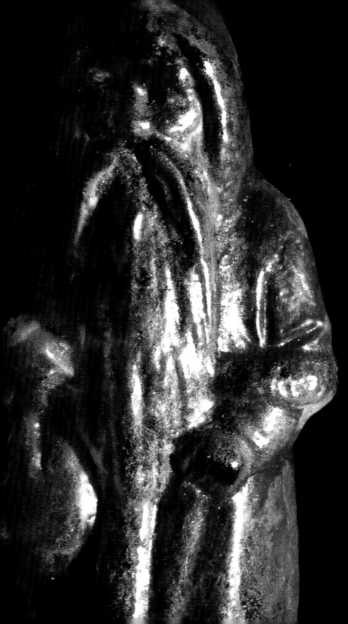

One year **MY FATHER** got it in his head to dress up as Santa and roller-skate through the mall. With his boom box slung over his shouder, he blared his tape of "Christmas Jollies" by the Salsoul Orchestra (all-disco versions of Christmas carols, which he plays continuously, to this day, during the holiday season). As he "jived" through the mall, he flung lollypops at the small children waiting patiently in line to see Mall Santa. They, of course, were transfixed by this new "funky" Santa and followed him like he was the Pied Piper. Pops was in his glory. My mother always claims that his behavior is the result of being attention-deprived growing up on a farm in Pennsylvania. When Mall Security finally caught up with him and his entourage of little sugar-fiends, they forcibly escorted him out—despite the pleas of "don't take Santa" from the little ones— and banned him forever from the Hollywood Fashion Center. — D

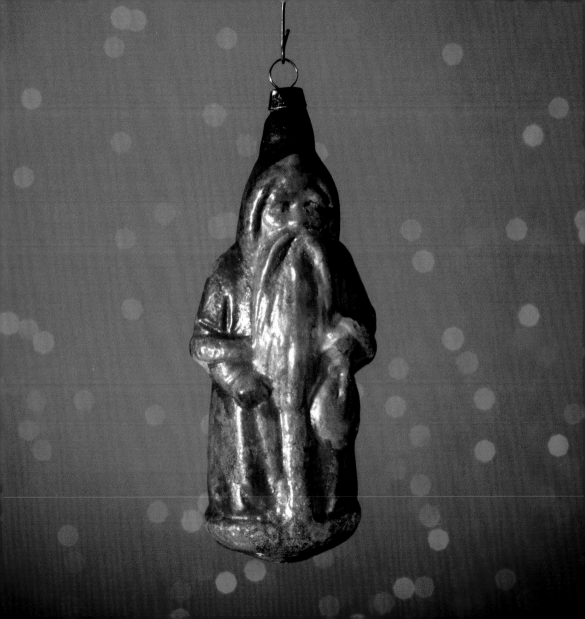

**RALPH** came running in. He was all excited about a box of fifty ornaments for sale on eBay. "'REAL OLD,' but there's no picture because the woman can't find the charger for her digital camera. She also doesn't like cardboard, so she threw away the old ornament boxes and re-packed them all in plastic containers!" He was willing to take a gamble. And since no one else would be fool enough to bid against him, he was sure we could get the whole lot REAL CHEAP! Well, it turns out there were *plenty* of fools out there willing to bid hard-earned cash on an unseen box-lot of old ornaments—but several weeks and a PayPal charge of $15 later, a gigantic box arrived filled to the brim with those horrible styrofoam peanuts that blew all over the studio and stuck to Linus with fierce static-electric cling. We breathlessly pulled out the first

plastic box and inside were…plastic, satin, and styrofoam creations from the 1970s (to some, "real old"). There were also handmade ceramic "Strawberry Shortcake" and "My Pretty Pony" knock offs and lots and lots of ordinary balls. Our hearts sank, but we eagerly tore into the next box like the crazed junkies that we are. Box after box, we groaned as we threw them aside until we came to the very last one. Finally there were some older, American-made ones: a bell, an "Odawara"-style Chinese lantern, and a clear ornament with tinsel inside. "Hey, these aren't bad!" said Ralph, seeking validation for his recklessness. Then we unwrapped this little guy—a clown Santa from around the 1940s with decal eyes! The "coop-de-grassy," as my father would proclaim…and the perfect **HAPPY ENDING** we had been hoping for all along.

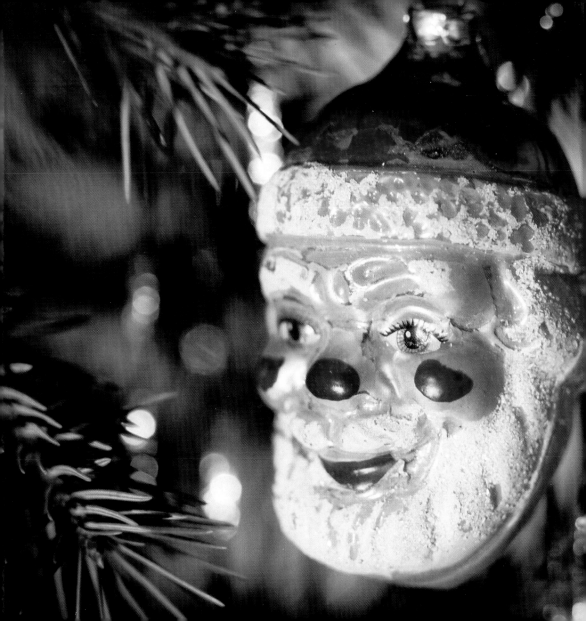

BYE

...see ya next year!